# BONDS

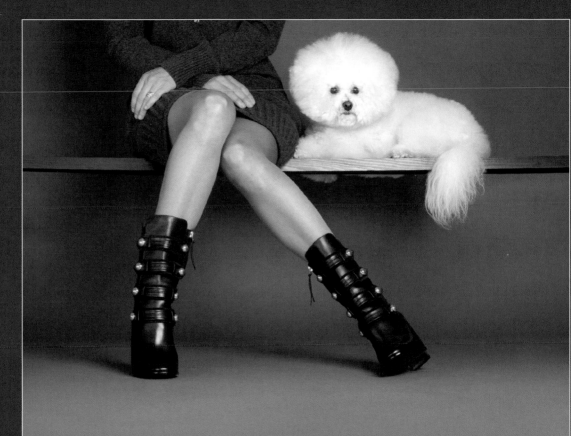

CAPTURING THE SPECIAL RELATIONSHIP THAT DOGS SHARE WITH THEIR PEOPLE

INDRE CUKURAITE • HELEN PAIS

Hubble & Hattie

The Hubble & Hattie imprint was launched in 2009 and is named in memory of two very special Westie sisters, whose people were Veloce's proprietors. Since the first book, many more have been added to the list, all with the same underlying objective: to be of real benefit to the species they cover, at the same time promoting compassion, understanding and respect between all animals (including human ones!) All Hubble & Hattie publications offer ethical, high quality content and presentation, and represent great value for money.

## Other great books from Hubble & Hattie –

A colourful kaleidoscope of accounts of the delights and benefits that dogs bring, by celebrities and other extraordinary people. All royalties donated to the Samaritans.

For the first time, an exploration of the human-animal bond from the male perspective

When rescue animals become therapy animals, the resultant human-animal connections are both therapeutic and healing. Animals who came in from the cold – and warmed the hearts of many!

The true story of the bond between a traumatised, one-eyed feral Romanian dog and the author, whose love and kindness transformed Charlie's life.

A collection of stories – some spooky, some funny, and some to make you think – about man's best friend. Facts, history and humour aplenty from around the world.

An often funny, sometimes melancholy, and occasionally accurate guide to understanding the relationship between a dog and a human – from this dog's perspective!

Back panel image –

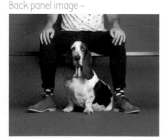

Thelma with Rob
Age: 6 years
Breed: Basset Hound
Rob: "Thelma is a devoted, chatty and impatient lady, with a heart even bigger than her ears"

First published February 2017 by Veloce Publishing Limited, Veloce House, Parkway Farm Business Park, Middle Farm Way, Poundbury, Dorchester, Dorset, DT1 3AR, England. Fax 01305 250479/ email info@hubbleandhattie.com/web www.hubbleandhattie.com ISBN: 978-1-845849-85-6 UPC: 6-36847-04985-0 ©Indre Cukuraite, Helen Pais & Veloce Publishing Ltd 2017. All rights reserved. With the exception of quoting brief passages for the purpose of review, no part of this publication may be recorded, reproduced or transmitted by any means, including photocopying, without the written permission of Veloce Publishing Ltd. Throughout this book logos, model names and designations, etc, have been used for the purposes of identification, illustration and decoration. Such names are the property of the trademark holder as this is not an official publication. Readers with ideas for books about animals, or animal-related topics, are invited to write to the editorial director of Veloce Publishing at the above address. British Library Cataloguing in Publication Data – A catalogue record for this book is available from the British Library. Typesetting, design and page make-up all by Veloce Publishing Ltd on Apple Mac. Printed in India by Replika Press.

Visit http://hubbleandhattie.com, and sign up to our great monthly newsletter, Animal Magic, for a fascinating and informative read!

# www.hubbleandhattie.com

For post publication news, updates and amendments relating to this book please visit www.hubbleandhattie.com/extras/HH4985, or scan the code

# CONTENTS

For dogs and people ... and dogs with people

# ACKNOWLEDGEMENTS

We are very grateful to everyone who has been involved in this project.
Special thanks go to Alfonso – for letting the light in, every day. And Robert – the sugar cubes were and still are a life-saver.
Last, but by no means least, our dogs, Morrissey and Orlando: what would we do without you?

# FOREWORD

If you have picked up this book, chances are that you are a dog-lover. And, like most of us who have this immeasurable bond with our furbabies, you've probably had a few – and possibly many – conversations with them.

When giving cues and requests, we can find ourselves rationalising and negotiating these, as our dogs gaze at us with perplexed looks, twitching eyebrows and tilted head, their innocent cuteness throwing us off, mid-sentence. At times we speak to our beloved companions at length, sharing what's on our mind when we need a listening ear – especially one that is non-judgemental.

Of course, we do not expect a vocal response, though still keenly observe their expressions, looking for indications that they understand what we are saying perfectly well. And sometimes we even answer on their behalf, using a different voice from ours, in a make-believe dialogue. What must they think of us?

Over centuries, humans and dogs have co-existed. But, in the last decade, there has been a significant increase in research into our canine companions – mainly cognitive studies – into understanding our canines, and the results have confirmed what we have instinctively known all along: our dogs possess a high level of understanding, emotion, and intelligence.

How often have we wished that they could speak, especially when they are unwell or unhappy. There is so much we would like to know about them – what they think and how they feel. Do they think that we, their besotted carers, are completely mad? And, of course, the question we really want to know the answer to: "Do you love me?"

In this fascinating collection of very personal and individual portraits taken from a unique perspective, the photographer, Indre Cukuraite, has used her camera lens as the interviewer, to let the dogs share their thoughts.

The result is *Bonds: capturing the special relationship that dogs share with their people*, an elegant, dignified and respectful photographic chronicle of the incomparable relationship that exists between us and

our dogs – as told *by* our dogs. The composition of the portraits (with one exception!) reflects the usual place where dogs are usually to be found, in relation to their owners, and it is in this familiar and secure spot that they are 'interviewed.' For me, this brings to mind an Edith Wharton quote: "My little dog – a heartbeat at my feet."

I first saw Indre's dog photography in her studio in Chelsea, London. I was immediately drawn to her portraits: the simplicity in composition and experimentation with lighting that captured the humanlike qualities in each subject made her work intriguing. The portraits made me pause and study the faces of these pups: they seemed to have something to say. Whether it was the trio of black Poodles huddled together like a family against a turquoise background, or the little white Maltese fluffball who looked like she owned the world, I lingered over each one – appreciating the beauty of the light, the details picked out, and the depth of expression on each of their faces.

As a keen observer of my own dogs' reactions to my tone of voice and movements (I am all too guilty of applying my interpretations to their reactions), I fantasise about

May, Darcy and George

what they think and feel, or imagine what their thought-bubble captions would be, and write their stories in our daily blog – 'Miss Darcy's Adventures.'

So, when Indre asked us to be a part of her book, we jumped at the chance to be interviewed, and both my pups most definitely have stories to tell! Darcy, my Cockapoo, came to me as a puppy. At three, her secure life was rudely interrupted by the arrival of George, a small but resourceful street dog from Hungary. The revised dynamic took a little while to settle, and at our photographic interview, Indre captured the relationship with me and with each other that existed then: little George attempting to be the dominant one, while Darcy was comfortable knowing her place in my heart.

Each of these captivating images reveals the depth of the close companionship that exists. You can read the captions or you can read the expressions told through body language or eyes. No two stories are the same. We love our dogs. They are God's angels in our midst.

May Ping Wong
Blogger of 'Miss Darcy's Adventures'

# INTRODUCTION

We read stories on faces every day. There are as many tales in our days as there are people we see. Some of the stories are gloomy, whilst others are amusing, heart-warming accounts of daily mishaps, experiences, relationships, and bonds we share. We look at faces to see how or what others are feeling, to help us know how to react or respond, and while thoughts can be put into words, emotions are best conveyed through non-verbal means – in a face and in photographs.

But what if you could not see the face? Would it make a difference? Would another story be told if only body language could be seen, and observed from an unusual angle, perhaps? What if, instead, you could see the face of someone nearby: someone very close important and special, with whom a profound bond is shared. A dog, say ...

This is a book about bonds, each fascinating and unique, yet united by the exceptional relationship and individual experiences they share with each other.

Take, for example, Fredi, a well-travelled Airedale Terrier, who came strutting into the studio as if about to board yet another train. His leadership skills, and 'chatty' mannerisms have kept his people amused and engaged in conversation over many years and journeys. Fredi had very strong opinions, views and ideas about this particular photoshoot, and took over the direction of it from the first pose.

Jay, the Border Collie, on the other hand, arrived as an apparent extension of his person's leg: tightly wrapped around it, and constantly seeking eye contact for further information. His need for comfort and familiar cues told the story of a very close and amusing relationship, developed by spending all day together.

Morrissey, the Manchester Terrier, literally barked the story of his confidence out loud, which was perfectly captured in the moment.

These are just some of the fascinating connections we were privileged to witness during the creation of this project. All of the individuals we met – canine and human – were incomparable, yet all shared one thing – a bond.

*Bonds* is a photographic account of the inimitable connection that dogs have with their people: a relationship observed and captured from their point of view.

Forty-two unparalleled images of four- and two-legged individuals sitting on a continuous bench showcase the different dynamics of each relationship. By not revealing the faces of the two-legged participants, the dogs get to tell their story their way, yet this also allows the reader to study and consider the body language of each, and make up their own story, perhaps.

Each image is accompanied by a doggy pearl of wisdom, elicited by close observation of and listening to the canine stars of each photoshoot.

At the end of the book, you will find exclusive interviews with the dogs' people, who each repeat and confirm the irrefutable claim: "My dog is unique."

Please regard the book with a touch of whimsy; it can be enjoyed from front to back or back to front. We very much hope that it brings a smile to the face and a heartfelt glow to everyone who has experienced the special bond between dogs and those who love them.

We hope you enjoy reading the book as much as we enjoyed creating it.

Indre and Helen

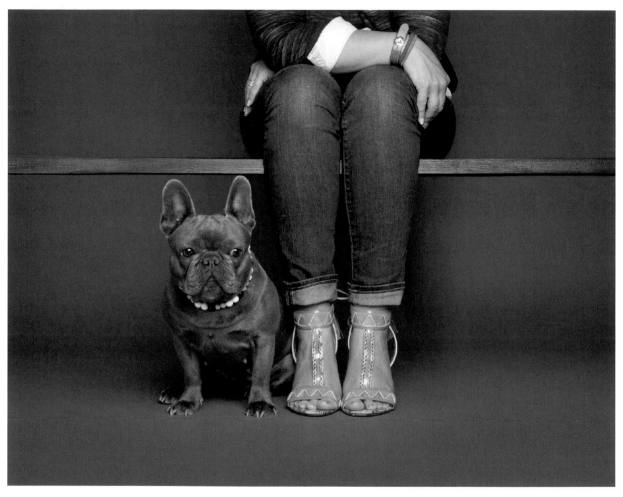

"Life isn't always perfect, but the shoes can be" – Harper

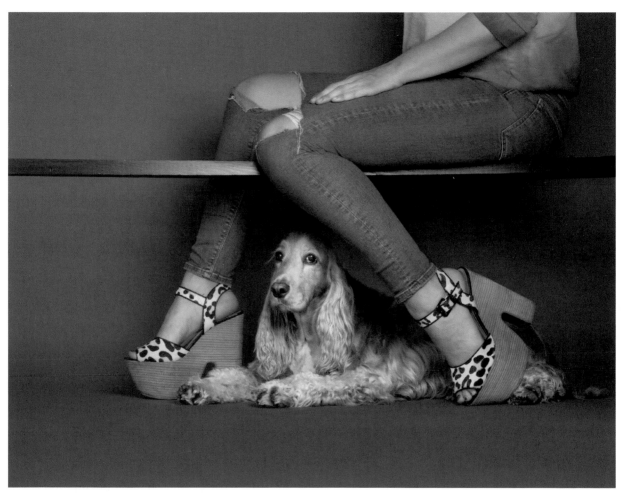

"When we are in the car and a sad song comes on the radio, we stare out the window and act like we're in a movie" – Maisie

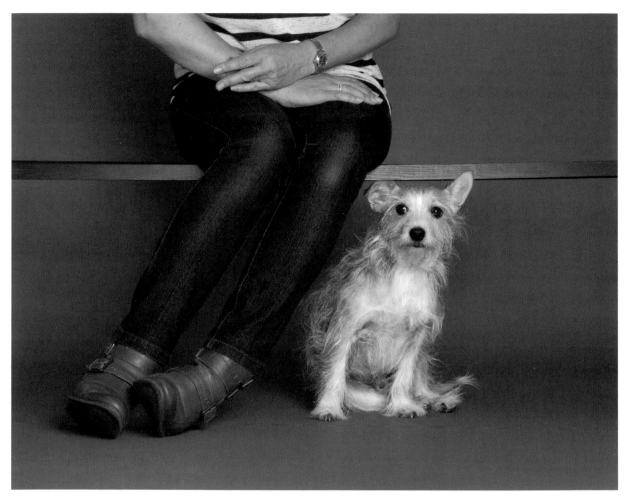

"You speak to me with words and I look at you with feelings" – Archie

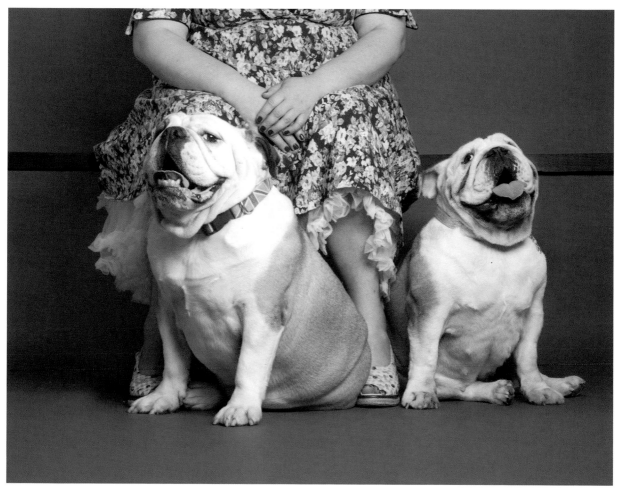

"Once you get past the charm, good looks, intelligence, sense of humour ... we think it's our modesty that stands out" – John and Gladis

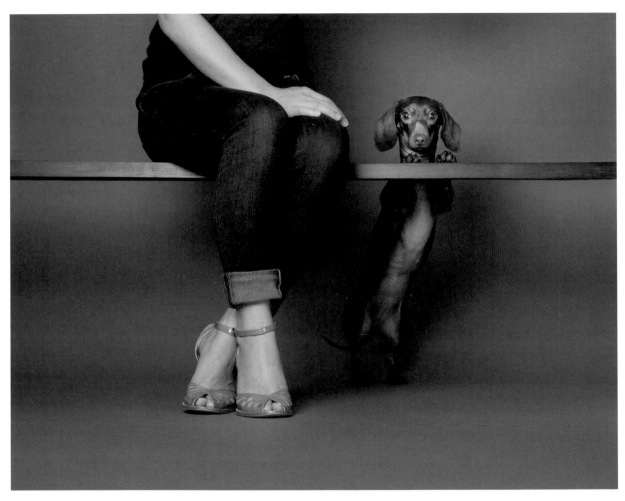

"My life should have background music: I would play drums" – Mabel

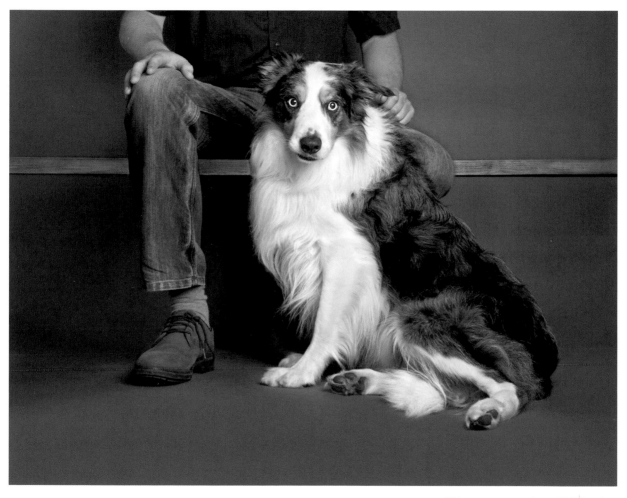

"We connect without WiFi" – Jay

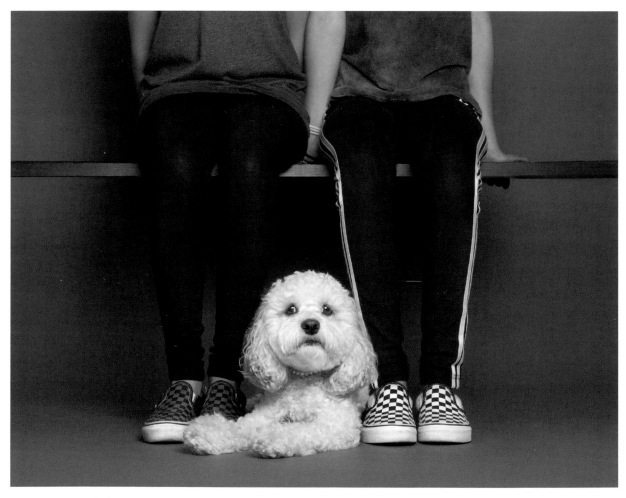

"We can rise and shine. Just not at the same time" – Valentina Fey

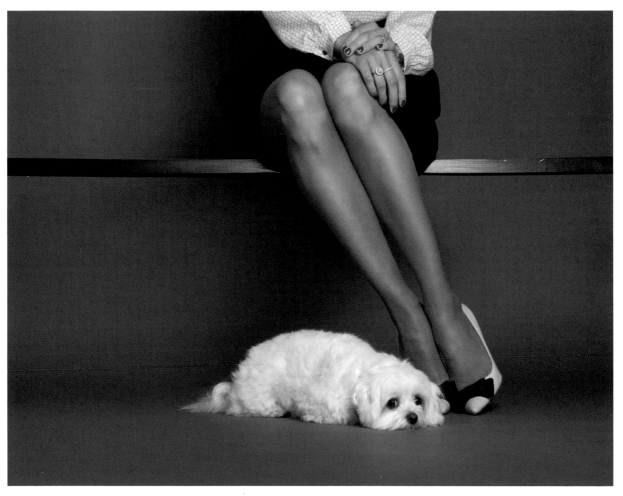

"We haven't shopped in three days; we don't even know who we are anymore" – Dolly

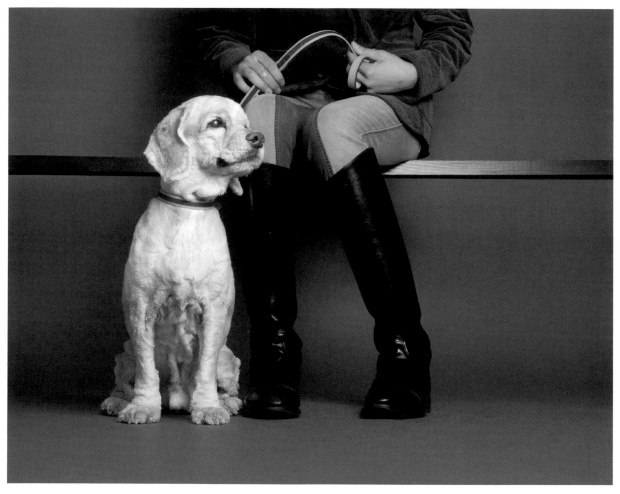

"What brought us together? Fate? Destiny? No, a horse" – Macaroon

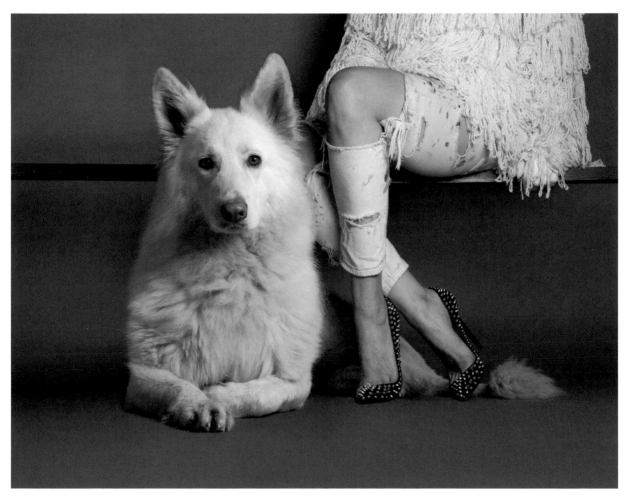

"Beautiful, balanced and elegant, with an overlying spicy resonance ... and that's just her" – Rose

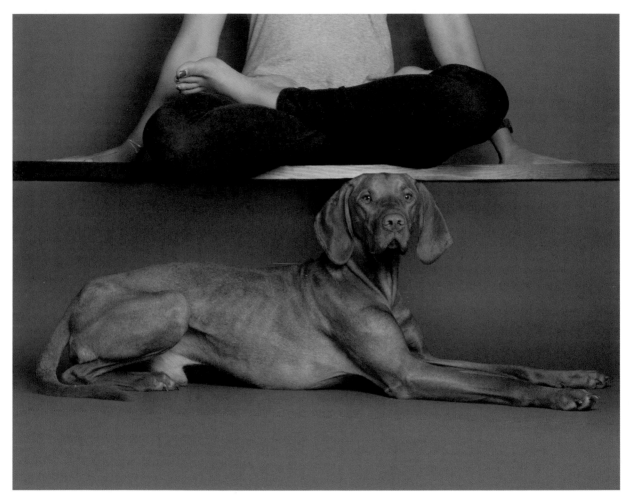

"C'mon inner peace, I don't have all day!" – Apollo

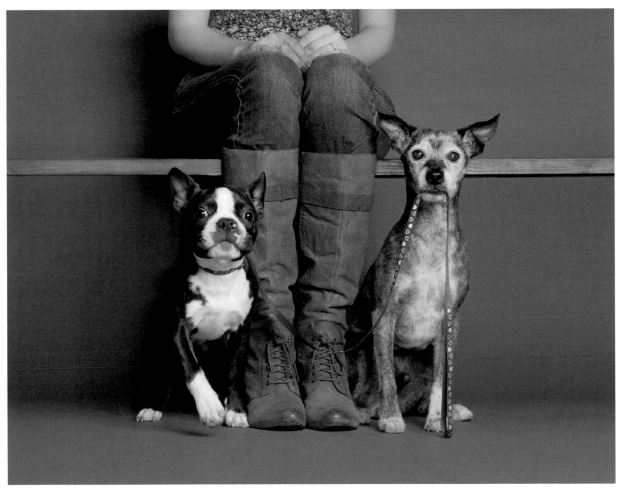

"Every story is beautiful, but ours is my favourite" – Blossom and Blaze

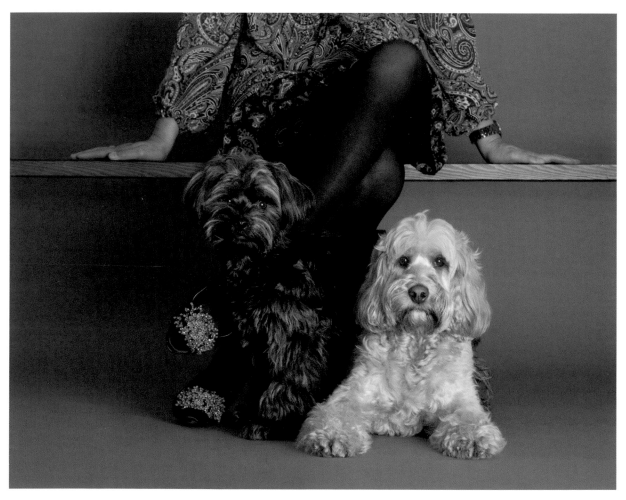

"Yes, she is single. No, she is not available" – George and Darcy

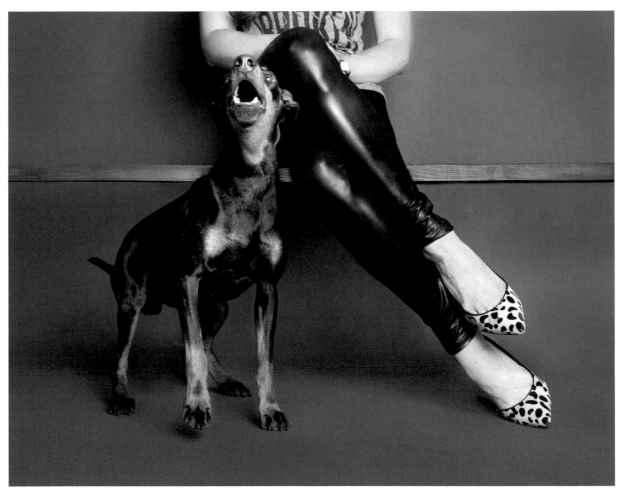

"We always behave. Just not necessarily well" – Morrissey

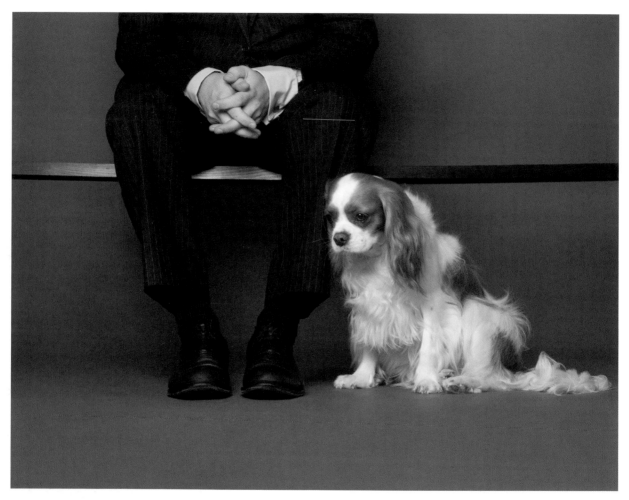

"At times I think to myself, where did I find this weirdo? But then I think, what would I do without him?" – Harry

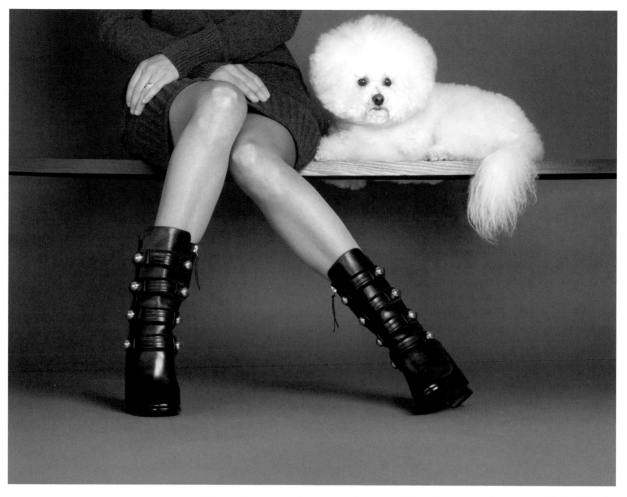

"Sometimes we chase our demons. Other times we simply cuddle" – Charlie

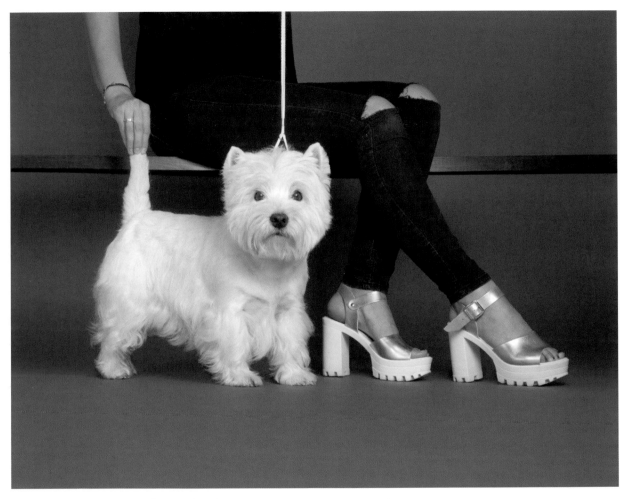

"The show must go on ... all over the place ... am I wrong?" – Raymond

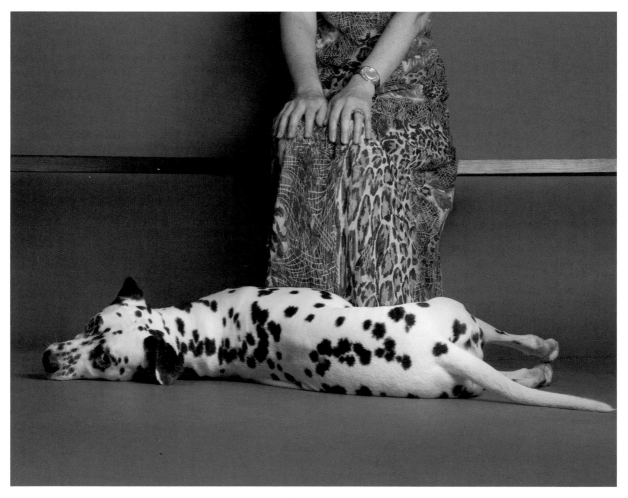

"*Chicken* is the answer. Wait, what was the question?" – Barlow

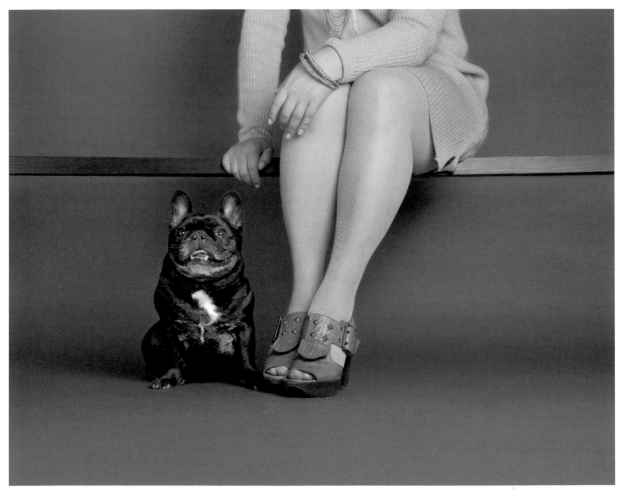

"I think we bought champagne instead of milk ... again" – Elle

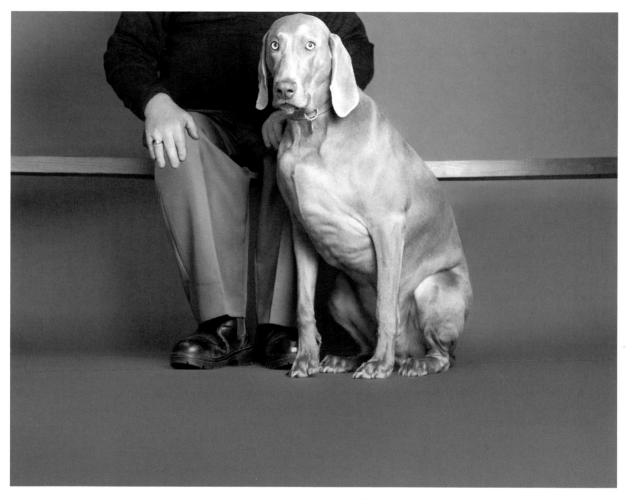

"Love is all that matters – and all that I can give"   Chase

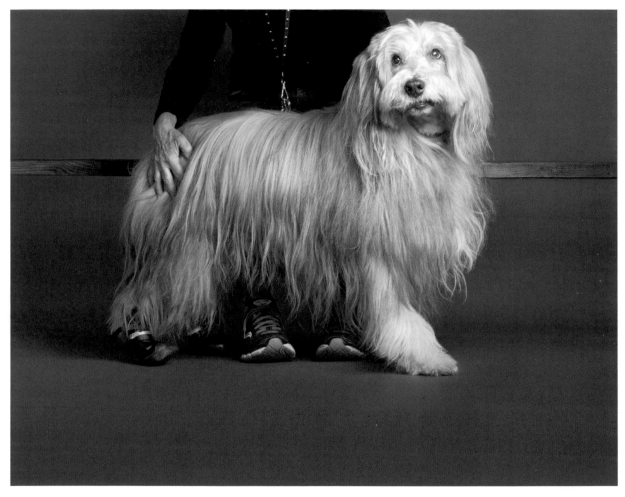

"We do up our shoelaces and keep on trucking" – Jake

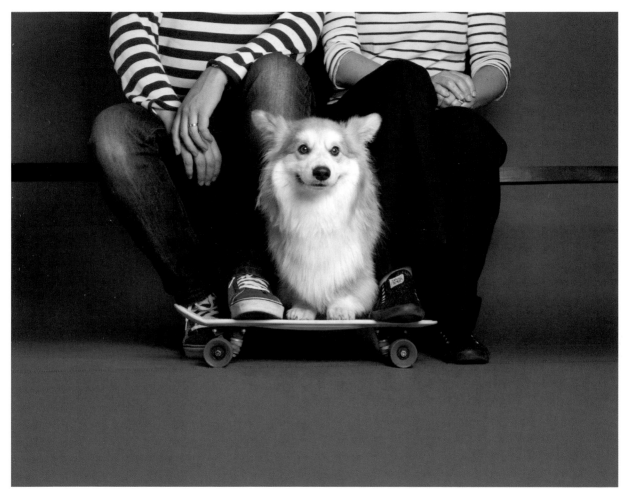

"Me and my guys are the funniest people I know" – Marcel

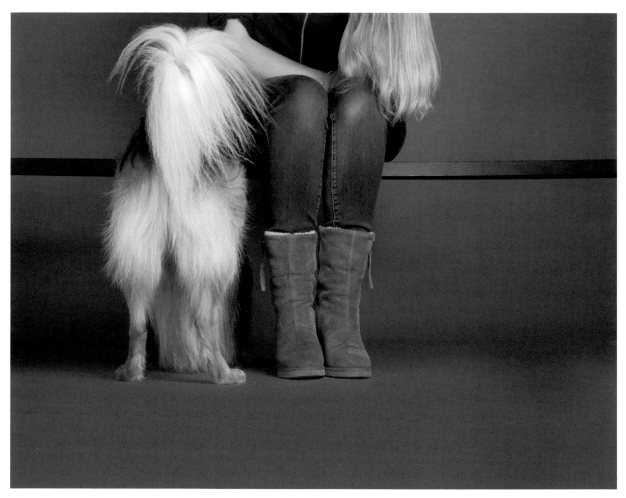

"I dig, you dig, we dig, he dig, she dig, they dig ... Hey! It might not be a beautiful poem, but it's very deep"
- Chase

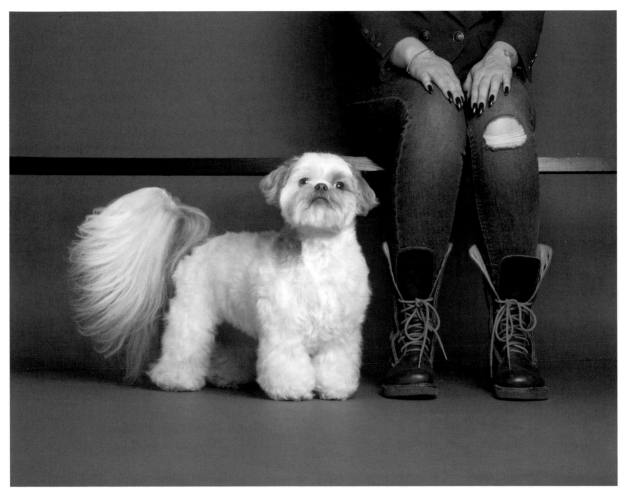

"I only associate with those who stimulate my intellect" – Gizmo

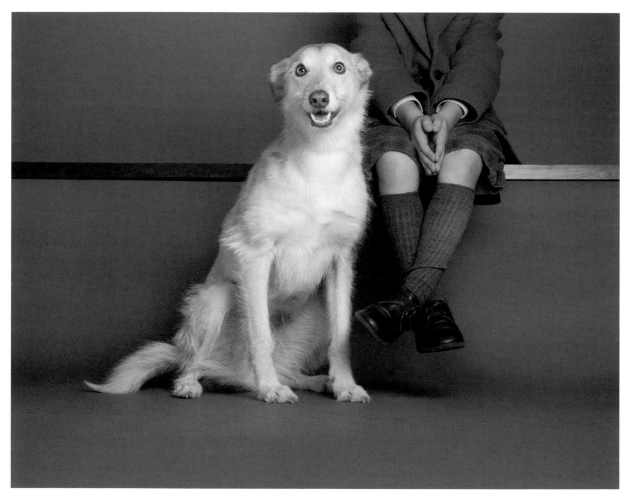

"We mostly like to stand outside. Because we are outstanding" – Nika

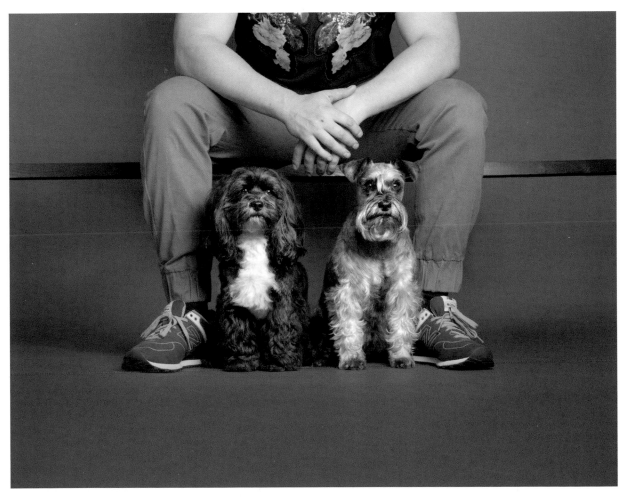

"We broke up with the gym. It wasn't working out" – Gipsy and Bibi

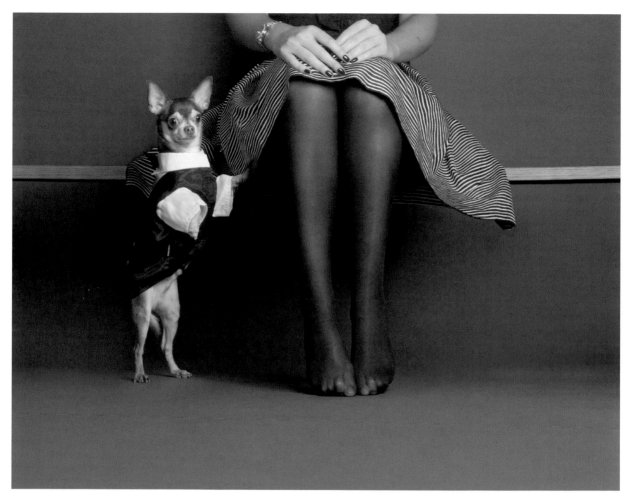

"Besides duck fillet, she is my favourite" – Chaplin

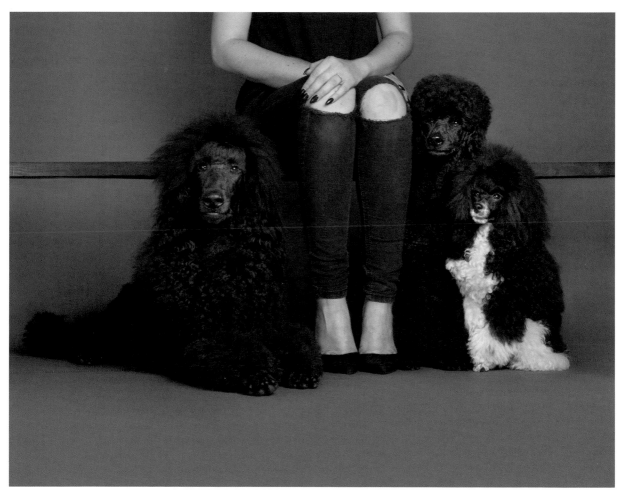

"She is PhD: professional hairdresser" – Boss, Manny and Fedor

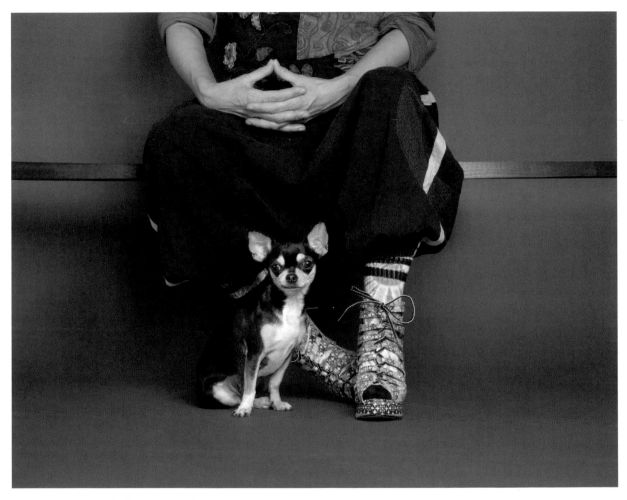

"I have nothing to declare except her genius" – Tita

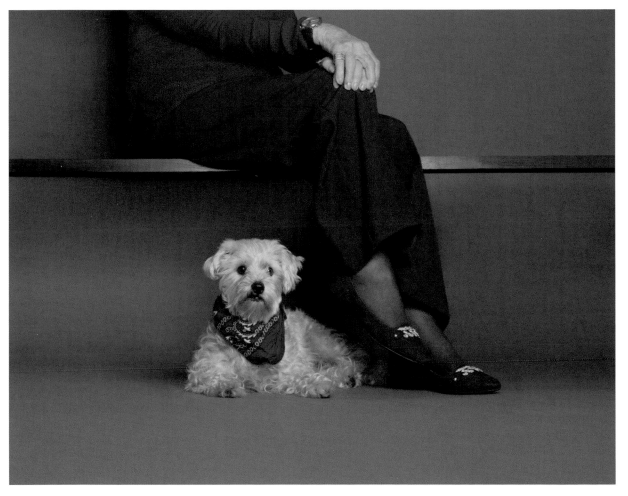

"Well behaved women – who's heard of them?" – Marley

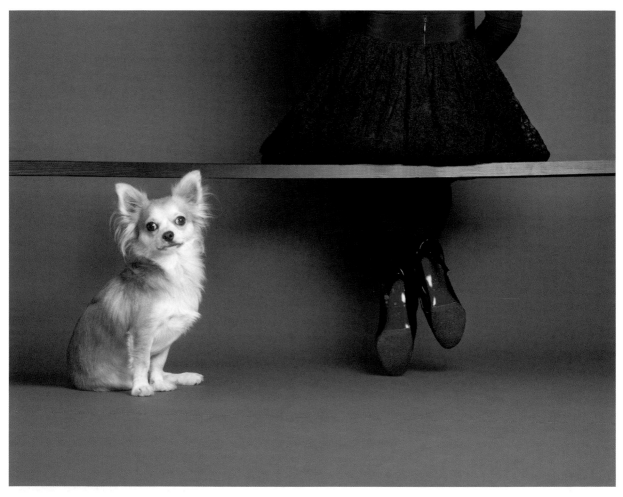

"She calls me Rocky; I call her amazing" – Rocky J

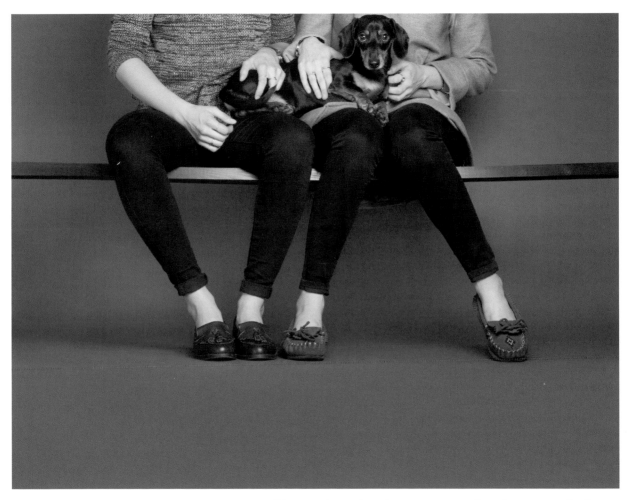

"Yes, we do cardio ... by running social media accounts" – Bruno

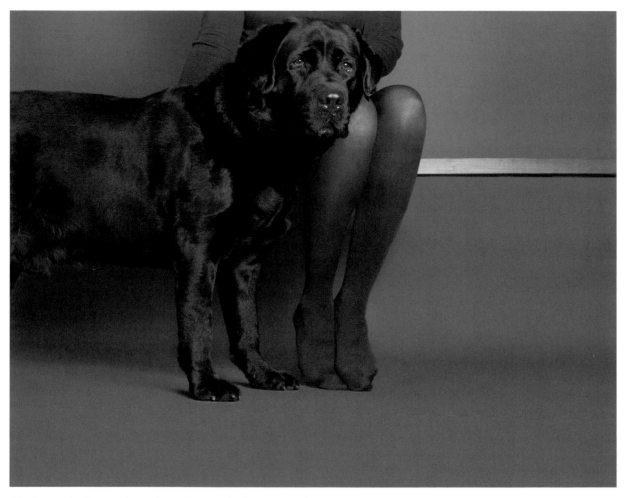

"Yeah, we think outside ... oh, we forgot the box" – Curtly

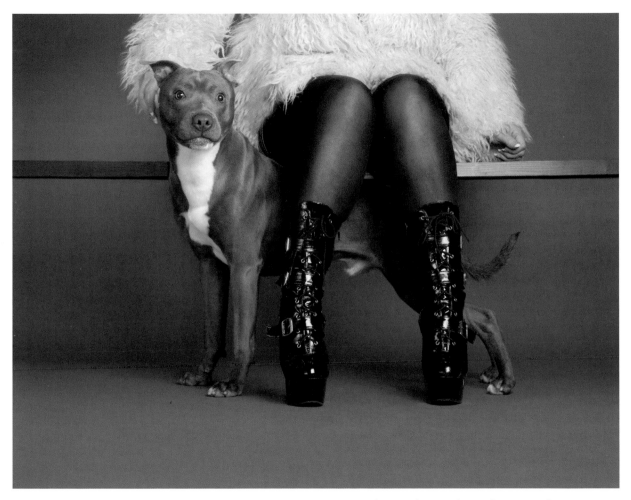

"Every day is a first-night performance for us" – Paco

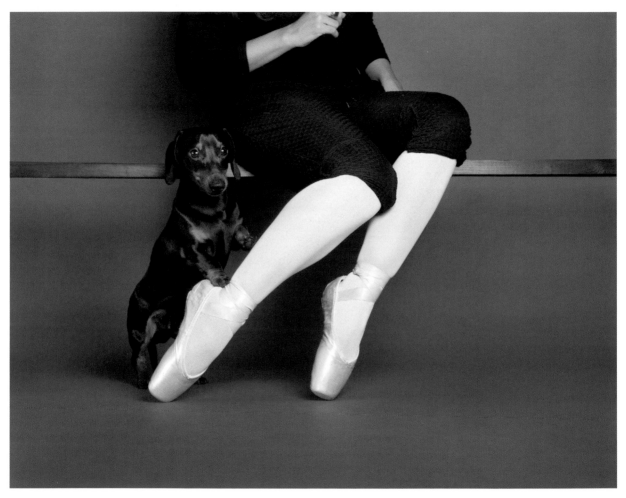

"Relationships are kinda strange. There's a person, and you're, like, 'oooh, yes!' Then you just do stuff together"
– Monty

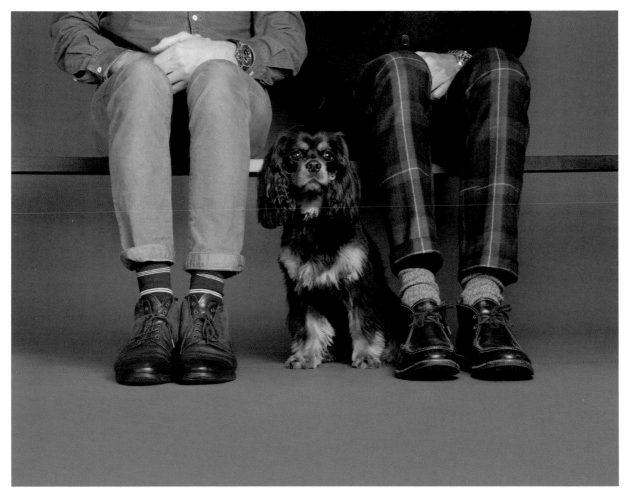

"Style personified" – Foxy

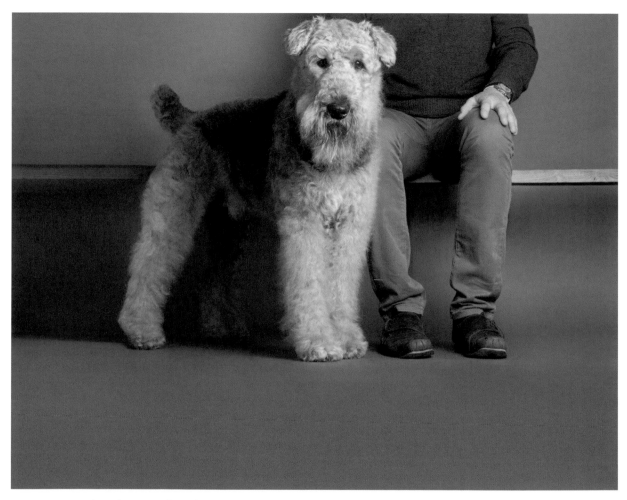

"Doors: open/closed/open/closed – and then there are the hallways ..." – Fredi

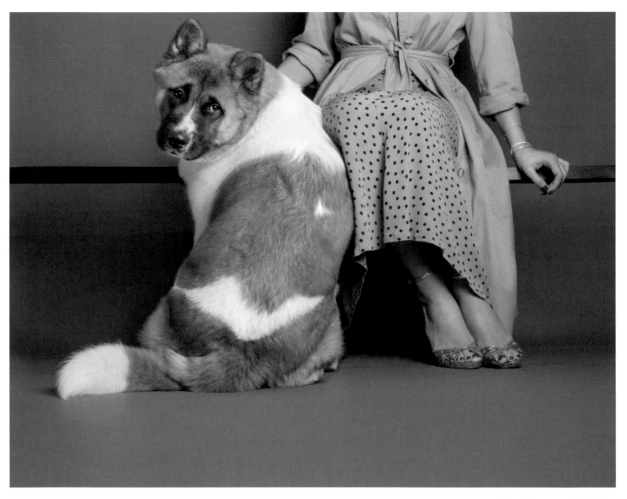

"Chic happens" – Lobo

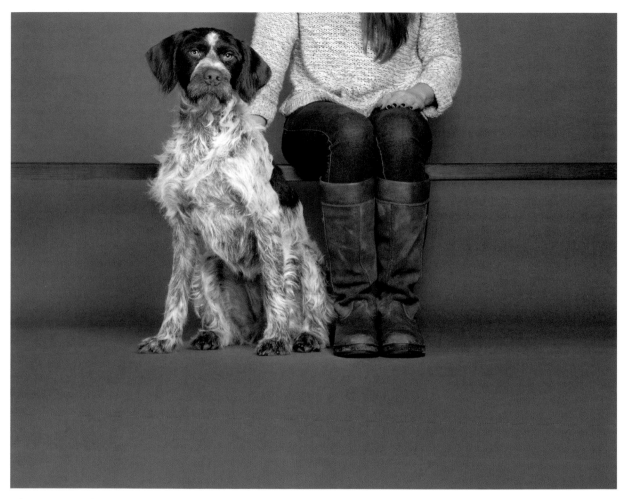

"There are two kinds of people in the world ... and she is one of them" – India

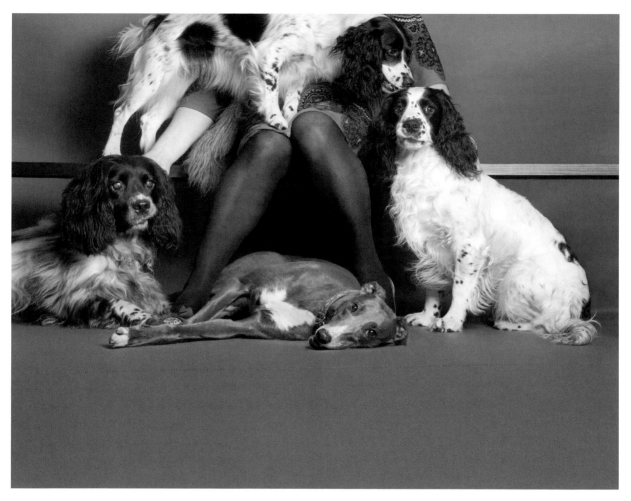

"Quick! Everyone act natural!" – Badger, Belle, Lannes and Lou

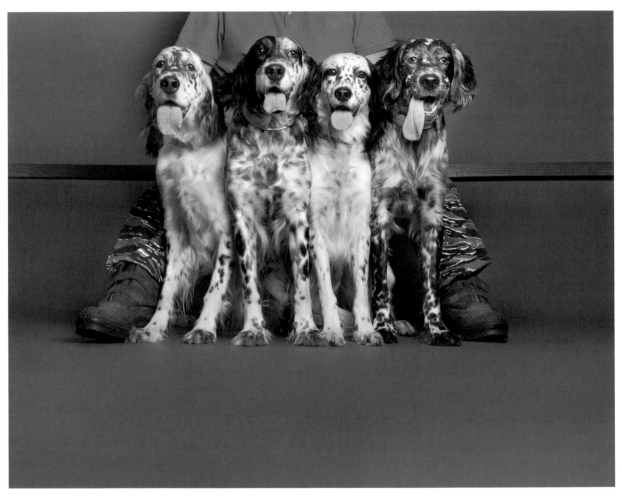

"We know how to set tongues wagging ..." – Anouk, Star, Luna and Basile

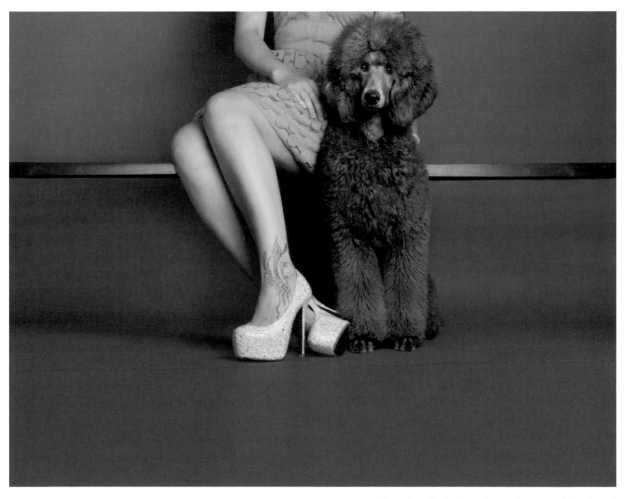

"Angelic attributes abound – mostly" – Pearl

# THEY SAY ...

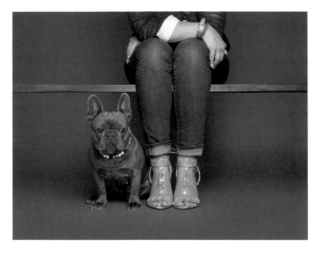

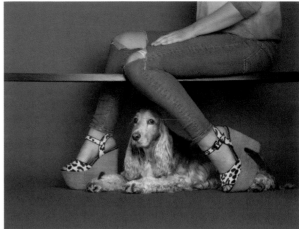

Harper with Helen
Age: 18 months
Breed: French Bulldog
Helen: "Harper is a sweet-natured professional model-about-town, with a penchant for cappuccino and shopping. She has a wardrobe and jewellery collection to rival that of a Russian oligarch"

Maisie with Jess
Age: 5 years
Breed: English Cocker Spaniel
Jess: "Maisie, the quiet biscuit connoisseur, loves swimming in lakes ... and mummy"

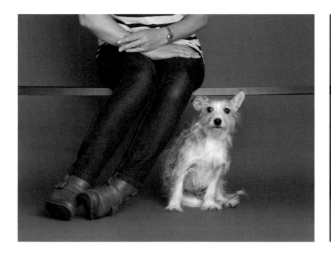

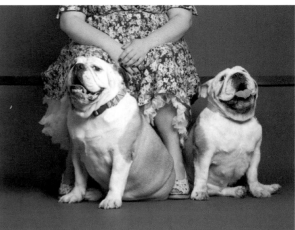

Archie with Jeanette
Age: around 8 years
Breed: Possibly a Jack Russell/Yorkshire Terrier cross
Jeanette: "People-magnet Archie is a loveable, happy little chap who likes racing in circles, cuddles, and tummy tickles"

John and Gladis with Simone
Age: both 3 years
Breed: English Bulldog
Simone: "Entrepreneurs John and Gladis own a pub in London, where they spend many hours of the day taking care of business"

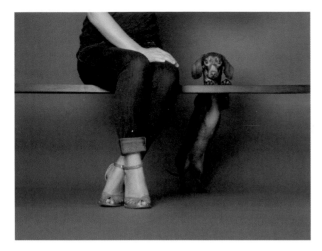

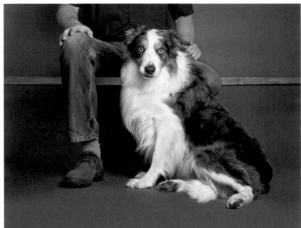

Mabel with Helene
Age: 4 years
Breed: Dachshund
Helene: "Mabel: largely little, often cheeky, and gives great
cuddles"

Jay with Rob
Age: 6 years
Breed: Border Collier
Rob: "When he is not hard at work herding tennis balls,
Jay likes to spend hours staring into pools of water,
contemplating the world that lies beneath"

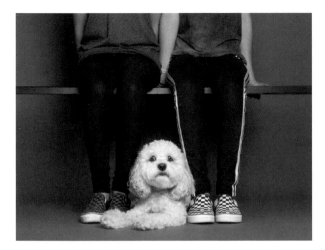

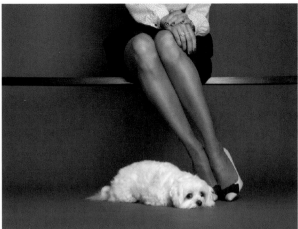

Valentina Fey with Vanessa and Lex
Age: 21 months
Breed: Cockapoo
Vanessa and Lex: "Named after Tina Fey of *Saturday Night Live* fame, Valentina has a keen sense of style and elegance, but also the right amount of swagger and bark"

Dolly with Maddie
Age: 3 years
Breed: Maltese
Maddie: "Aside from cucumber and nipping ankles, Dolly loves the finer things in life – pampering, cashmere, and designer collars – yet still manages to keep her paws firmly on the ground"

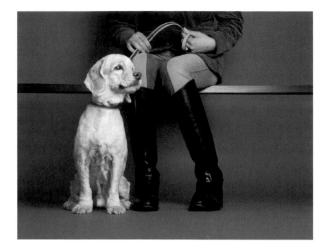

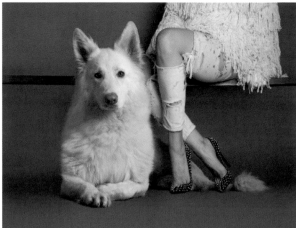

Macaroon with Shizuko
Age: 14 years
Breed: American Cocker Spaniel
Shizuko: "Big-hearted, optimistic and forgiving, Macaroon loves one word – FOOD!"

Rose with Malgosia
Age: 3 years
Breed: White German Shepherd
Malgosia: "She is my sleeping pill; I am her everything – what a privilege to be her Universe ... and have her in mine"

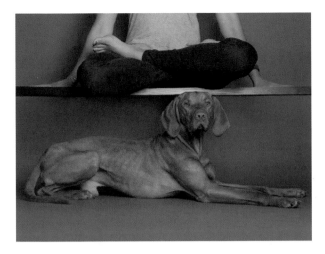

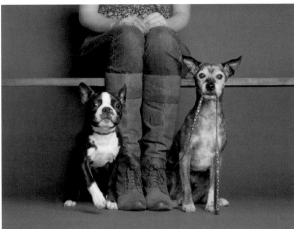

Apollo with Cecilia
Age: 18 months
Breed: Hungarian Vizsla
Cecilia: "Apollo's energy and happiness transfers to me, and brings a smile to my face every day. His curiosity and enthusiasm for world exploration remind me to be like him"

Blossom and Blaze with Marie
Age: 5 months and 12 years
Breed: Boston Terrier and Lakeland Terrier/Jack Russell cross
Marie: "Blossom and Blaze touch the hearts and souls of everyone, and bring smiles to faces that brighten up the day"

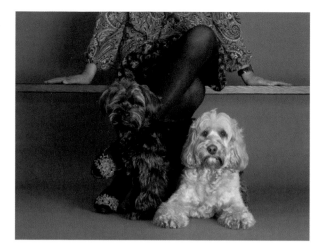 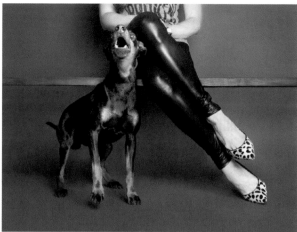

George and Darcy with May
Age: 4½ and 2 years
Breed: Crossbreed and Cockapoo
May: "Charmer George, the Heinz 57 rescue from the streets of Hungary, is engaging, and thinks he's the leader of the pack. Aloof, haughty, no-nonsense Miss Darcy is also a scavenger, and regally blond"

Morrissey with Helen
Age: 2 years
Breed: Manchester Terrier
Helen: "Morrissey is an opinionated person with a dry sense of humour, great negotiation skills, fab fashion sense, superb singing voice – and a six-pack"

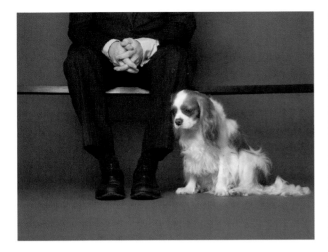

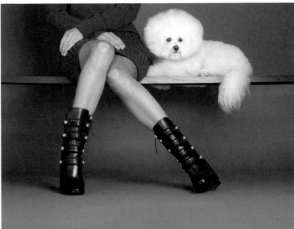

Harry with Michael
Age: 4 years
Breed: Cavalier King Charles Spaniel
Michael: "Harry is both a fun-loving racehorse and a couch potato, who loves me almost as much as he does biscuits"

Charlie with Christiana
Age: 8 years
Breed: Bichon Frise
Christiana: "Charlie is a dancing prima donna, drama queen, and committed attention-seeker: our heartbeat of the home"

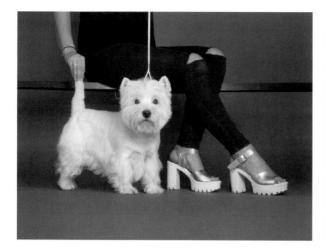 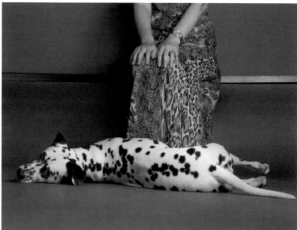

Raymond with Jessica
Age: 10 years
Breed: West Highland Terrier
Jessica: "Raymond is a well-travelled, cheeky and talkative ex-show dog, who likes to twirl on the spot and paddle in the river on a sunny day"

Barlow with Kate
Age: 4 years
Breed: Dalmatian
Kate: "Named after the famous singer Gary, the stubborn Barlow loves chicken and running ... and then some chicken *after* running"

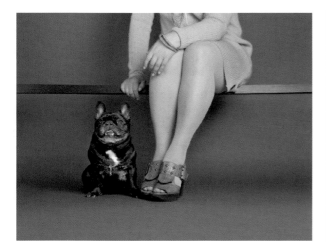

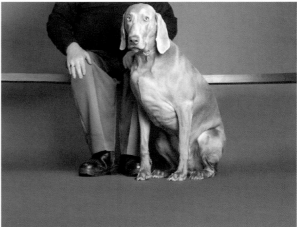

Elle with Coco
Age: 5 years
Breed: French Bulldog
Coco: "Elle is an international dog model and winner
of hearts, from newborn babies to acclaimed singer
Sam Smith"

Chase with Ian
Age: 22 months
Breed: Weimaraner
Ian: "Chase is a connoisseur of beds, which are carefully
positioned in prime locations around the house, yet, at
night, he sleeps with me. The wife has to sleep in another
room"

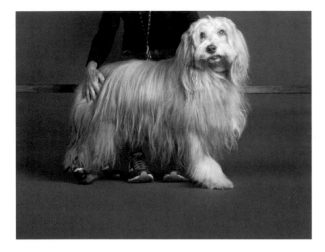

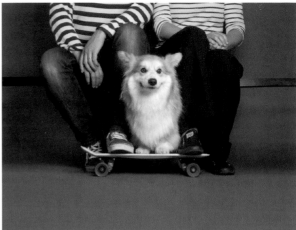

Jake with Karen
Age: 14 years
Breed: Bearded Collie
Karen: "Jake is smart as a whip, very gregarious, loves people – and never wants to go home after a walk"

Marcel with Aurelie and Pierre
Age: 2½ years
Breed: Pembroke Welsh Corgi
Aurelie and Pierre: "Marcel – a happy and sociable pup with the eyebrows of a wise Chinaman – is a well-travelled cordon bleu, who barks in English and French"

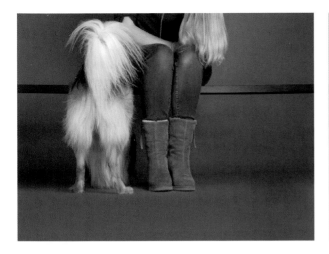

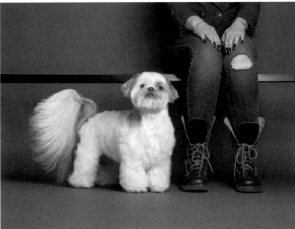

Chase with Vanessa
Age: 1 year
Breed: Special Greek Mix
Vanessa: "From Greek gutter to fancy strutter. Prepare to have your heart stolen"

Gizmo with Dione
Age: 7 years
Breed: Shih Tzu
Dione: "The regal and independent Gizmo is strong-willed, and only befriends four-legged individuals with curly hair who like bananas"

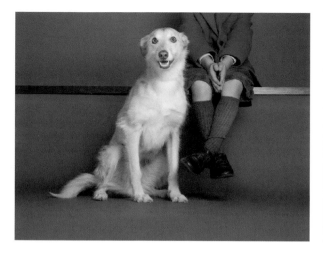

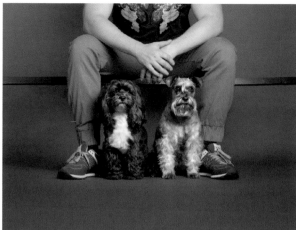

Nika with Henry
Age: 4 years
Breed: Lurcher
Henry: "Nika is a sixty-mile-an-hour couch potato, who loves to run like the wind, then take a good, long nap"

Gipsy and Bibi with Ryan
Age: 8 and 7 years
Breed: Lhasapoo and Miniature Schnauzer
Ryan: "Affectionate Gipsy makes sure she gets her own way, and Bibi, the squishable howler, loves squirrels and popcorn"

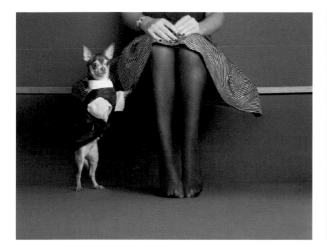
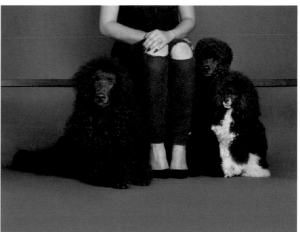

Chaplin with Diana
Age: 4½ years
Breed: Chihuahua
Diana: "Chaplin is an exceptionally smart little gentleman,
with a particular love of dancing for lettuce"

Boss, Manny and Fedor with Charlie
Age: 1, 6 and 1 year
Breed: Standard Poodle, Miniature Poodle, and Toy Poodle
Charlie: "They are strong-willed, quirky characters who like
to use me as a pillow"

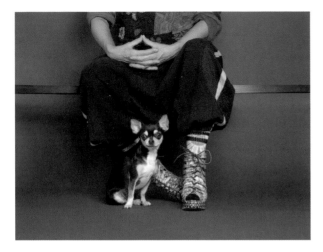

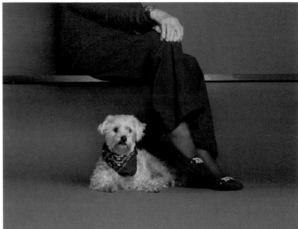

Tita with Becki
Age: 3 years
Breed: Apple Head Chihuahua
Becki: "Tita is a sweet-natured Elvis impersonator, fashion model, and artist's muse, whose bark is rare, but big"

Marley with Afdera
Age: around 5 years
Breed: Crossbreed
Afdera: "Marley enjoys a social life that allows him to express his superiority, since he has five different breed characters in his make-up"

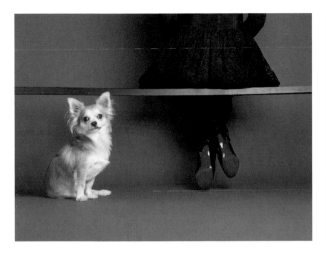

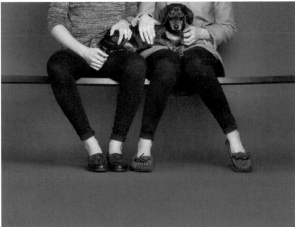

Rocky J with Linda
Age: 2 years
Breed: Cream Chihuahua
Linda: "Rocky is a world traveller with more air miles than most CEOs"

Bruno with Lindsay and Sarah
Age: 2½ years
Breed: Dachshund
Lindsay and Sarah: "With his acting skills and cuddling abilities, Bruno is a master of any and all situations"

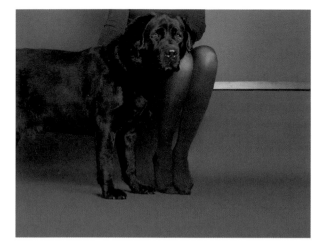

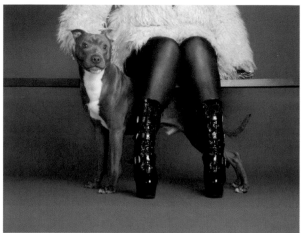

Curtly with Josie
Age: 5½ years
Breed: Labrador Retriever
Josie: "Curtly is a Basque Land-Rover, and captain of the muddy waters. But, behind his formidable exterior, there lies a pussycat"

Paco with Trinity
Age: 8 months
Breed: Staffordshire Bull Terrier
Trinity: "Paco is a trusted friend; a tough, yet soft, gentleman with a good listening ear"

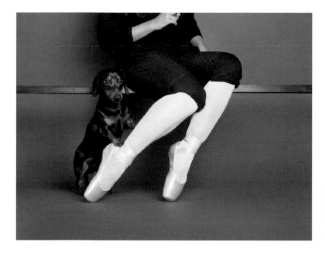

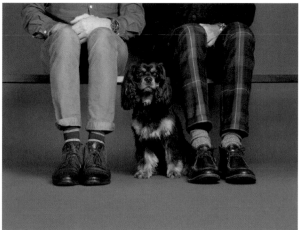

Monty with Yasmin
Age: 2 years
Breed: Miniature Dachshund
Yasmin: "Monty is known for his cute smile and waggy tail. He is a charming dog with lots of social media followers"

Foxy with Brian and Alex
Age: 2 years
Breed: Cavalier King Charles Spaniel
Brian and Alex: "When Foxy sees his favourite people, his tail wags so furiously it really is a case of the tail wagging the dog!"

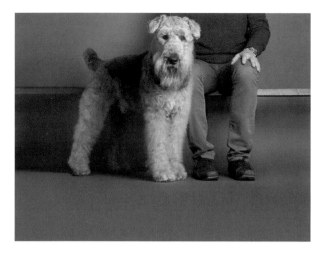

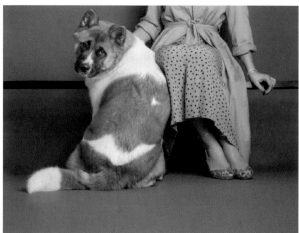

Fredi with Chris
Age: 10 years
Breed: Airedale Terrier
Chris: "Fredi's passion is travelling: London's Kings Road,
France's Champagne, New Zealand's Waiheke Island,
Switzerland's Zermatt, Italy's Cervinia. Retirement plans in
Ibiza are afoot ..."

Lobo with India
Age: 6 months
Breed: American Akita
India: "Lobo is a cuddly giant, who loves to spend his
working days at the gym greeting customers with a
beautiful howl"

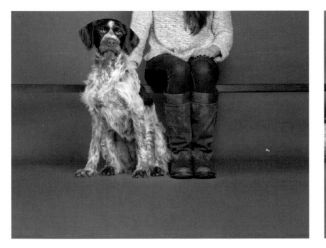

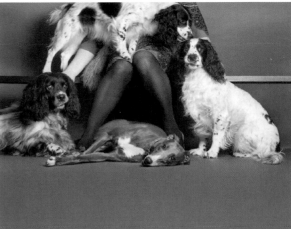

India with Natalie
Age: 2 years
Breed: German Wirehaired Pointer
Natalie: "When India, Queen of the Countryside, is not on pheasant patrol, she assumes her role as Lady of the Manor, receiving belly rubs from her 'staff'"

Badger, Belle, Lannes and Lou with Sarah
Age: 2, 3, 3 and 10 years
Breed: Three English Springer Spaniels and a Greyhound
Sarah: "The Three Musketeers enjoy an active lifestyle, whilst Lou prefers to sunbathe"

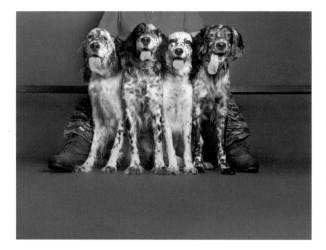 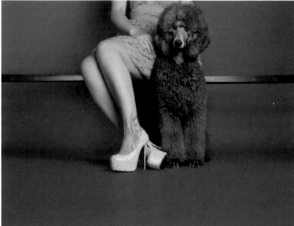

Anouk, Star, Luna and Basile with Mike
Age: 4, 7, 3 and 1 year
Breed: Working English Setters
Mike: "There's no hiding from them: they sniff you out like a piece of pie"

Pearl with Lia
Age: 14 months
Breed: Standard Poodle
Lia: "Life and soul of the household, Pearl, our long-legged Bambi, is very loyal and loving, and adores chasing tennis balls"